Draw 50 Outer Space

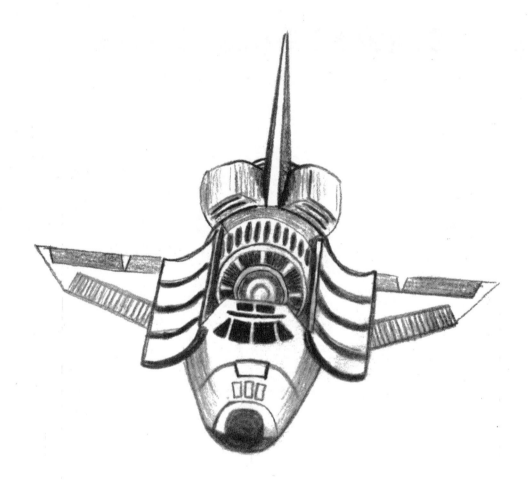

Outer Space

THE STEP-BY-STEP WAY TO DRAW
Astronauts, Rockets, Space Stations, Planets,
Meteors, Comets, Asteroids, and More

LEE J. AMES

with Erin Harvey

WATSON·GUPTILL
CALIFORNIA | NEW YORK

CONTENTS

TO THE READER

This book will show you a way to draw subjects related to outer space and outer space exploration. You need not start with the first illustration. Choose whichever you wish. When you have decided, follow the step-by-step method shown. *Very lightly* and *carefully*, sketch out the first step. However, this step, which is the easiest, should be done *most carefully*. The next step is added right to the first one, also lightly and also very carefully. The thrid step is sketched right over numbers one and two. Continue this way to the last step.

It may seem strange to ask you to be extra careful when you are drawing what seem to be the easiest first steps, but these are the most important, for a careless mistake at the beginning may spoil the whole picture at the end. As you sketch out each step, watch the spaces between the lines, as well as the lines, and see that they are accurate. After each step, you may want to lighten previous steps by pressing it with a kneaded eraser (available at art supply stores).

When you have finished, you may want to redo the final step in India ink with a fine brush or pen. When the ink is dry, use the kneaded eraser to clean off the pencil lines. The eraser will not affect the India ink.

Here are some suggestions: In the first few steps, even when all seems quite correct, you might do well to hold your work up to a mirror. Sometimes the mirror shows that you've twisted the drawing off to one side without being aware of it. At first you may find it difficult to draw the egg shapes, or ball shapes, or sausage shapes, or to just make the pencil go where you wish. Don't be discouraged. The more you practice, the more control you will develop.

The only equipment you'll need will be a medium or soft pencil, paper, a kneaded eraser, and, if you wish, a pen or brush and ink.

The first steps in this book are shown darker than necessary so that they can be clearly seen. (Keep your work very light.)

Remember there are many other ways and methods to make drawings. This book shows just one method. Why don't you seek out other ways from teachers, from libraries, and—most important—from inside yourself?

—Lee J. Ames

TO THE PARENT OR TEACHER

"David can draw a jet plane better than anybody else!" Such peer acclaim and encouragement generate incentive. Contemporary methods of art instruction (freedom of expression, experimentation, self-evaluation of competence and growth) provide a vigorous, fresh-air approach for which we must all be grateful.

New ideas need not, however, totally exclude the old. One such is the "follow me, step by step" approach. In my young learning days, this method was so common, and frequently so exclusive, that the student became nothing more than a pantographic extension of the teacher. In those days it was excessively overworked.

This does not mean that the young hand is never to be guided. Rather, specific guiding is fundamental. Step-by-step guiding that produces satisfactory results is valuable even when the means of accomplishment are not fully understood by the student.

The novice with a musical instrument is frequently taught to play simple melodies as quickly as possible, well before he learns the most elemental scratchings at the surface of music theory. The resultant self-satisfaction and pride in accomplishment can be a significant means of providing motivation. And all from mimicking an instructor's "Do as I do. . . ."

Mimicry is a prerequisite for developing creativity. We learn the use of our tools by mimicry. Then we can use those tools for creativity. To this end I would offer the budding artist the opportunity to memorize or mimic (rotelike, if you wish) the making of "pictures." "Pictures" he or she has been anxious to draw.

The use of this book should in no way be compulsory. Rather it should be available to anyone who *wants* to try another way of flapping his wings. Perhaps he will then get off the ground when his friend says, "David can draw a jet plane better than anybody else!"

—Lee J. Ames

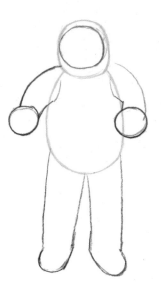
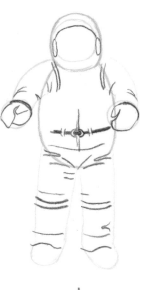
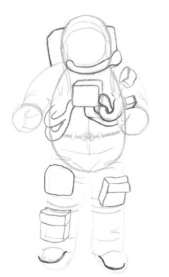
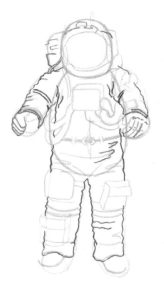
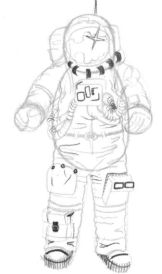
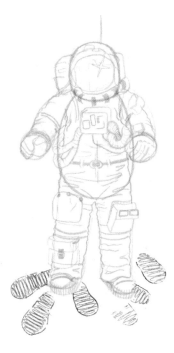
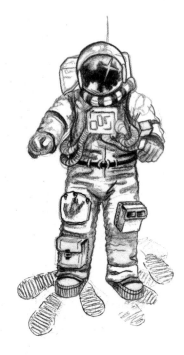

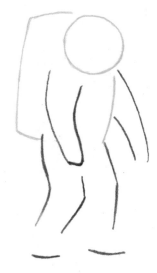

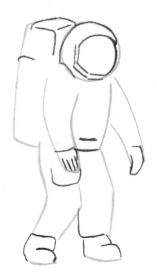

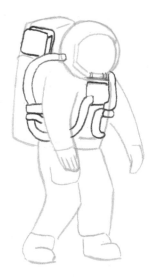

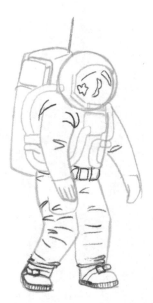

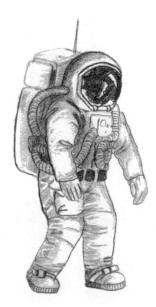

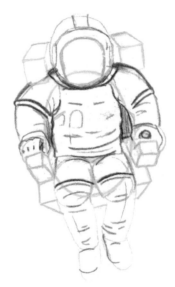

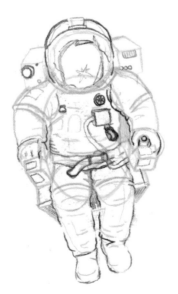

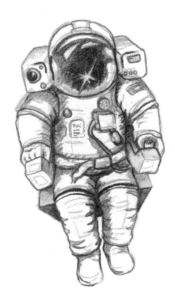

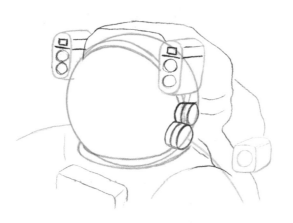

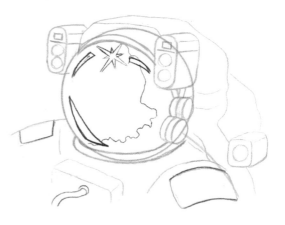

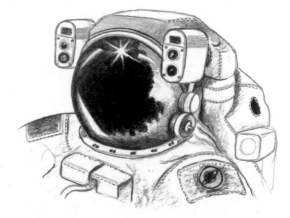

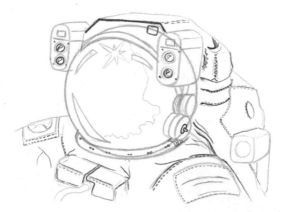

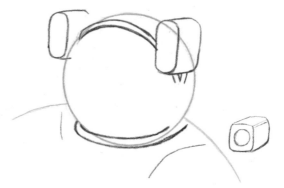

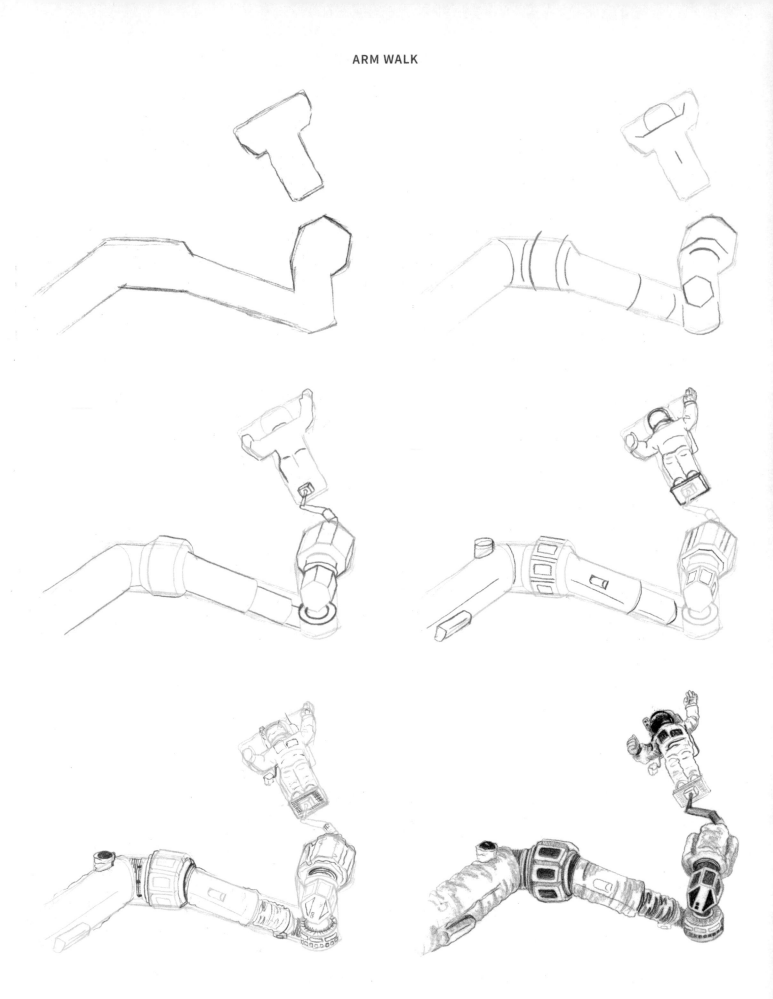

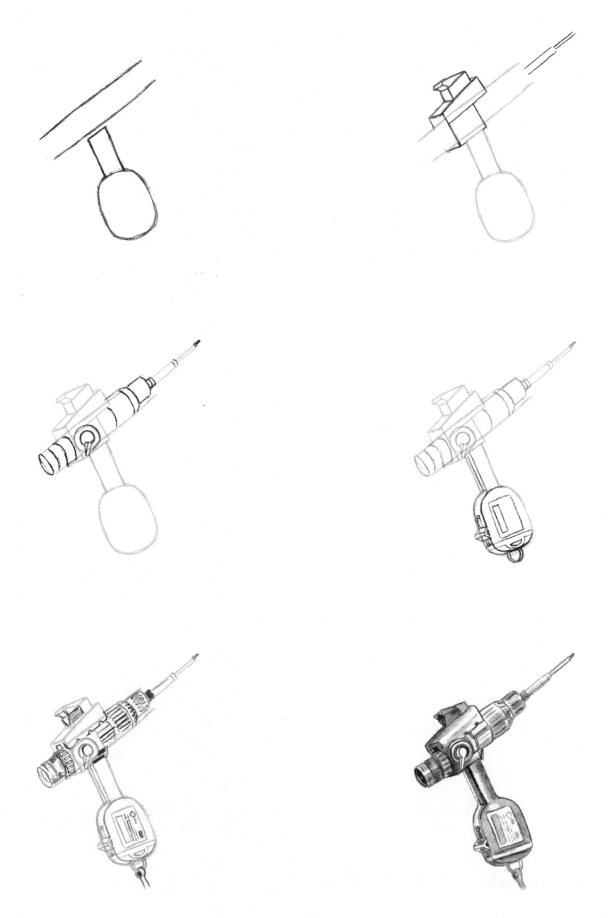

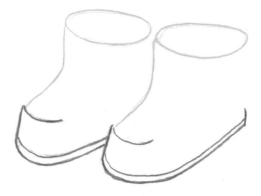

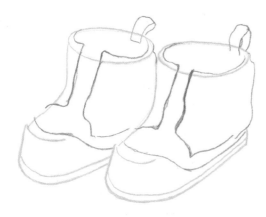

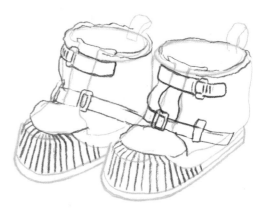

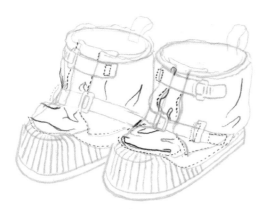

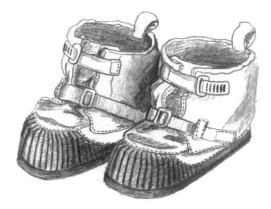

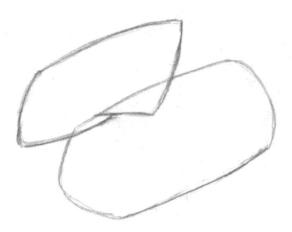

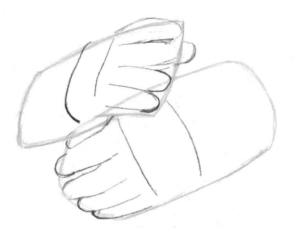

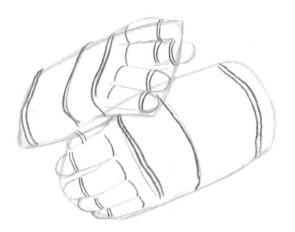

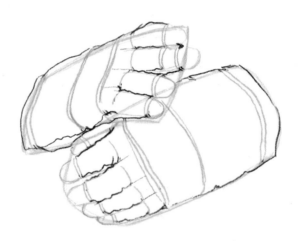

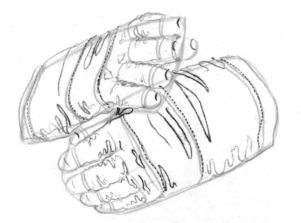

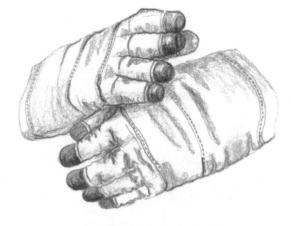

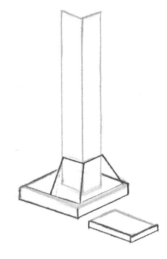

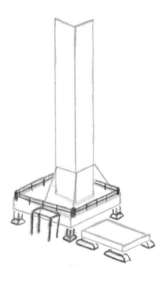

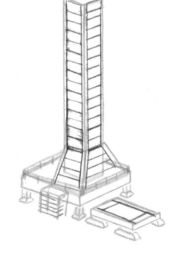

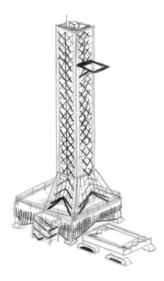

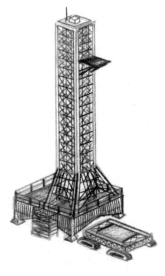

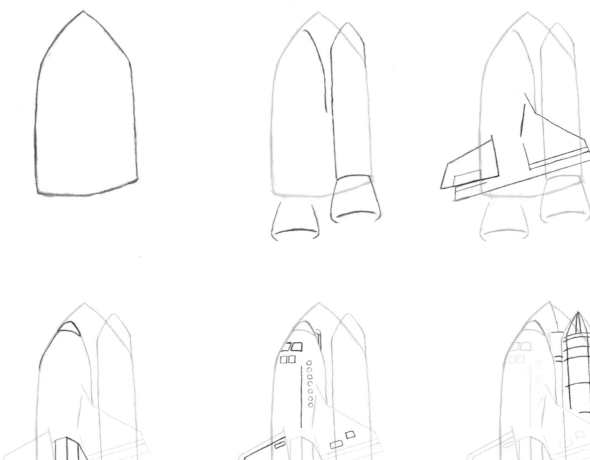

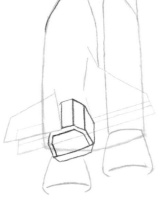

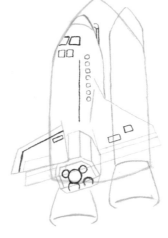

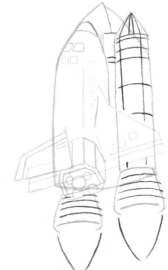

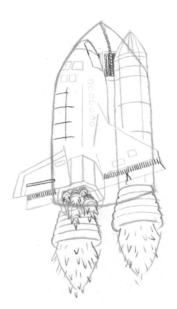

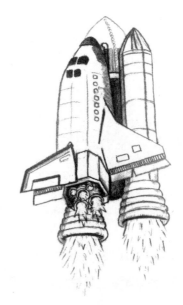

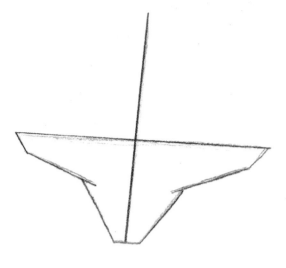
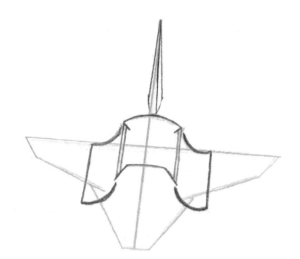
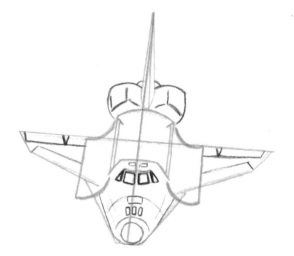
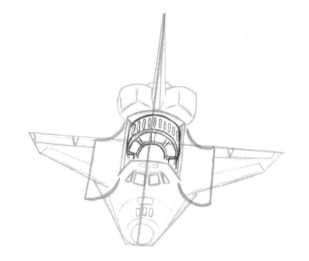
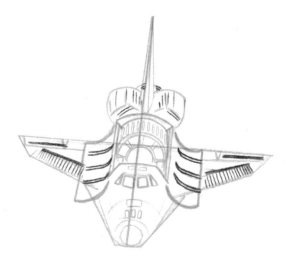
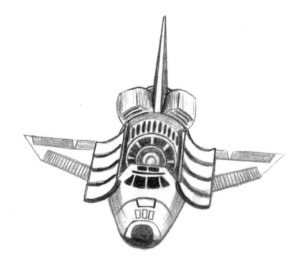

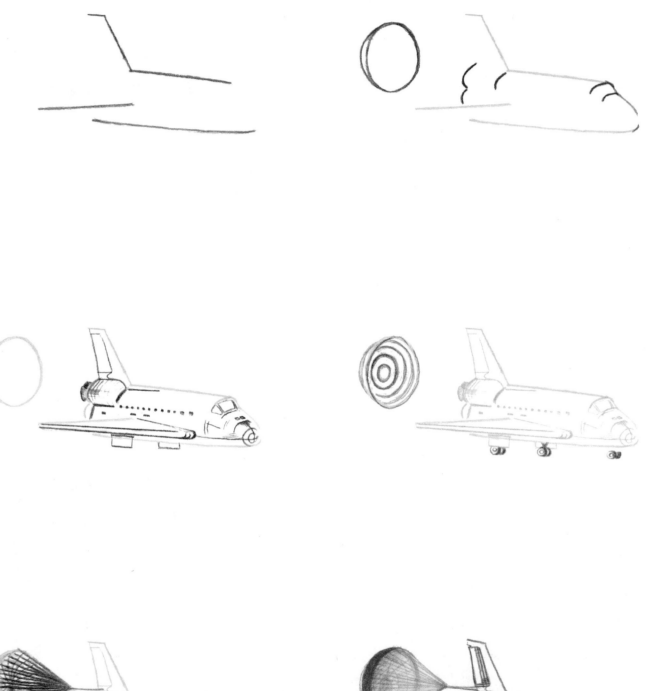

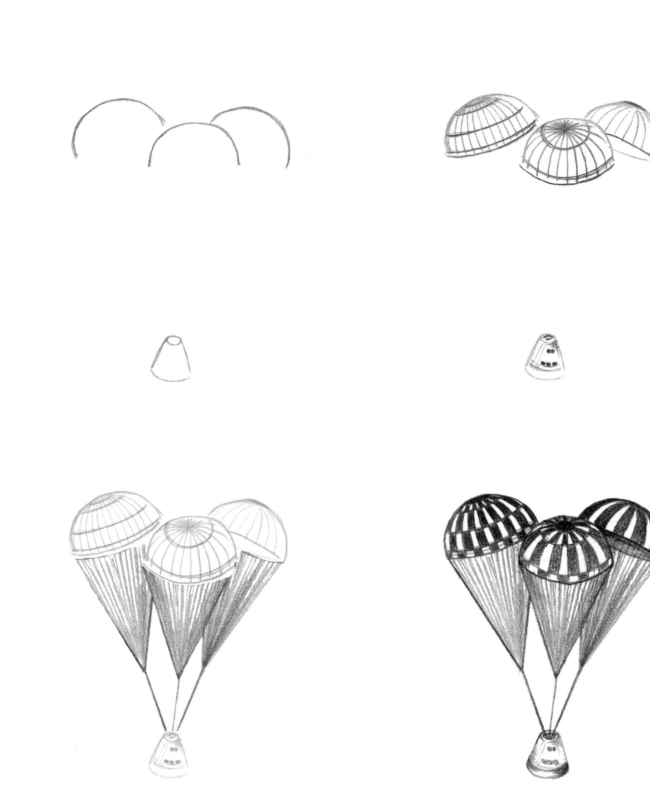

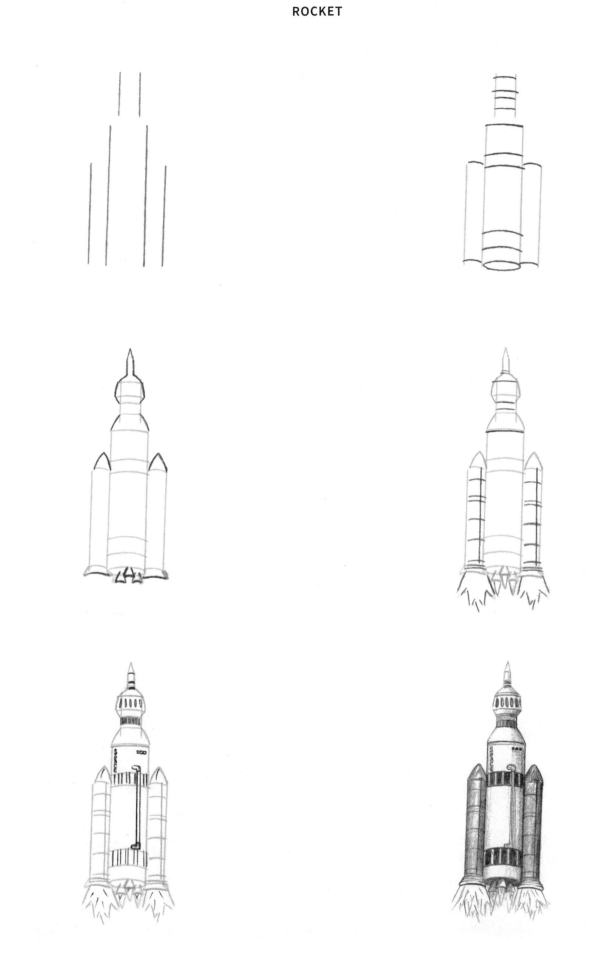

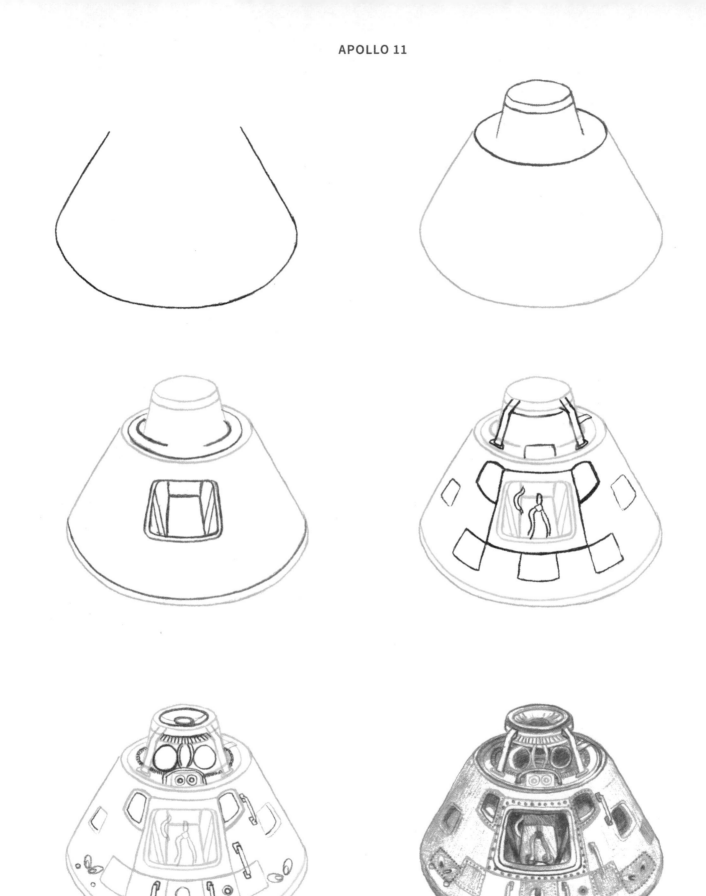

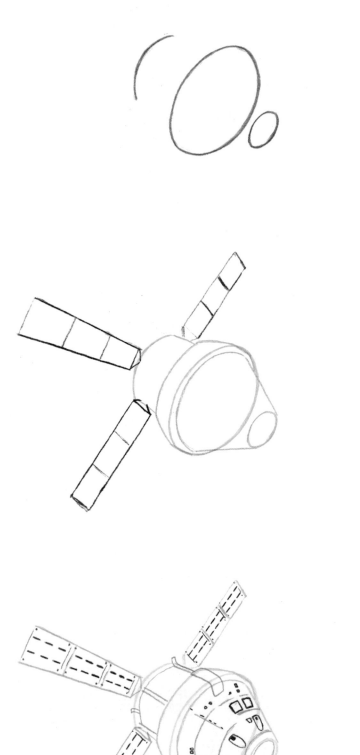
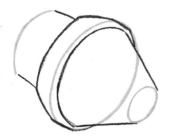
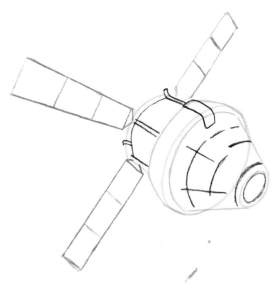
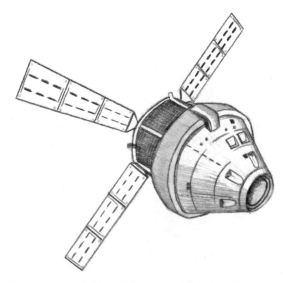

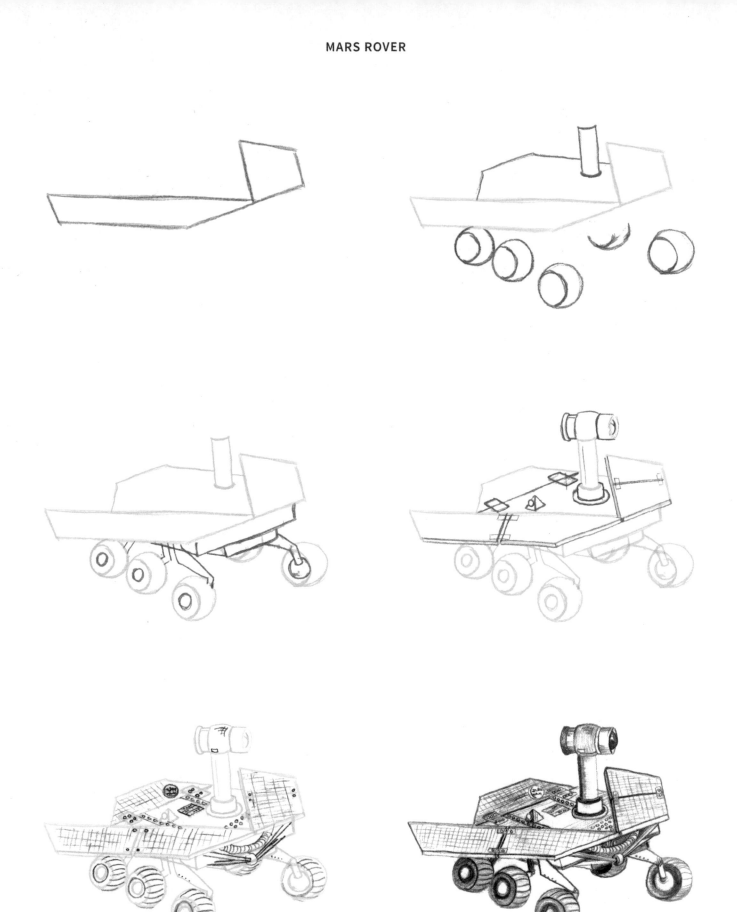

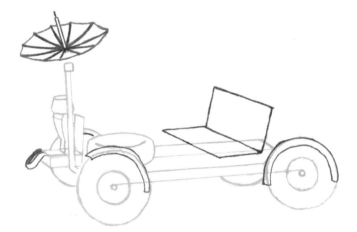

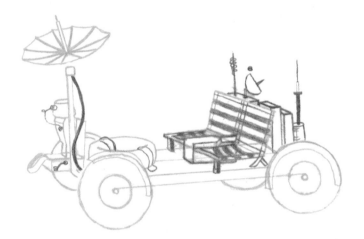

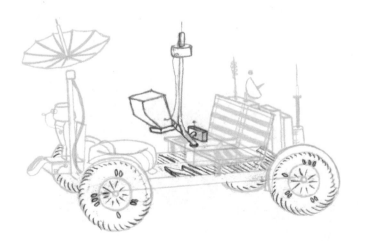

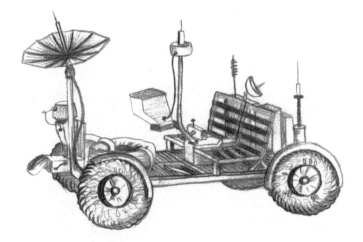

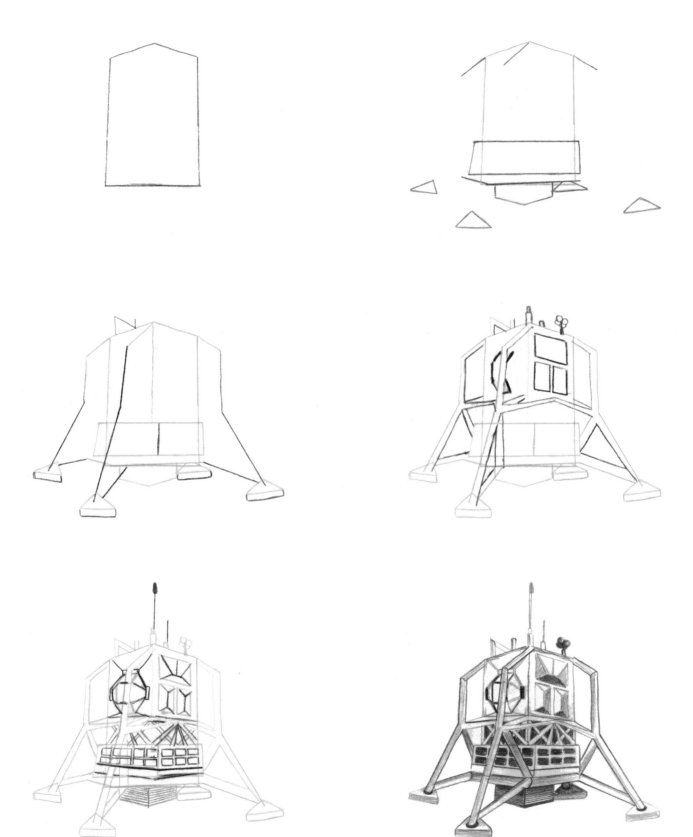

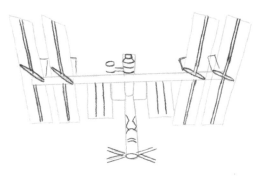

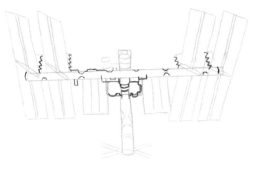

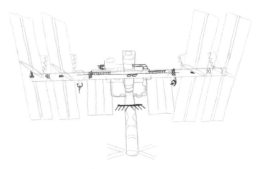

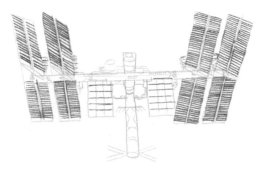

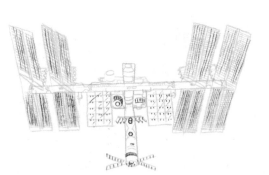

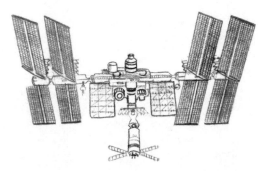

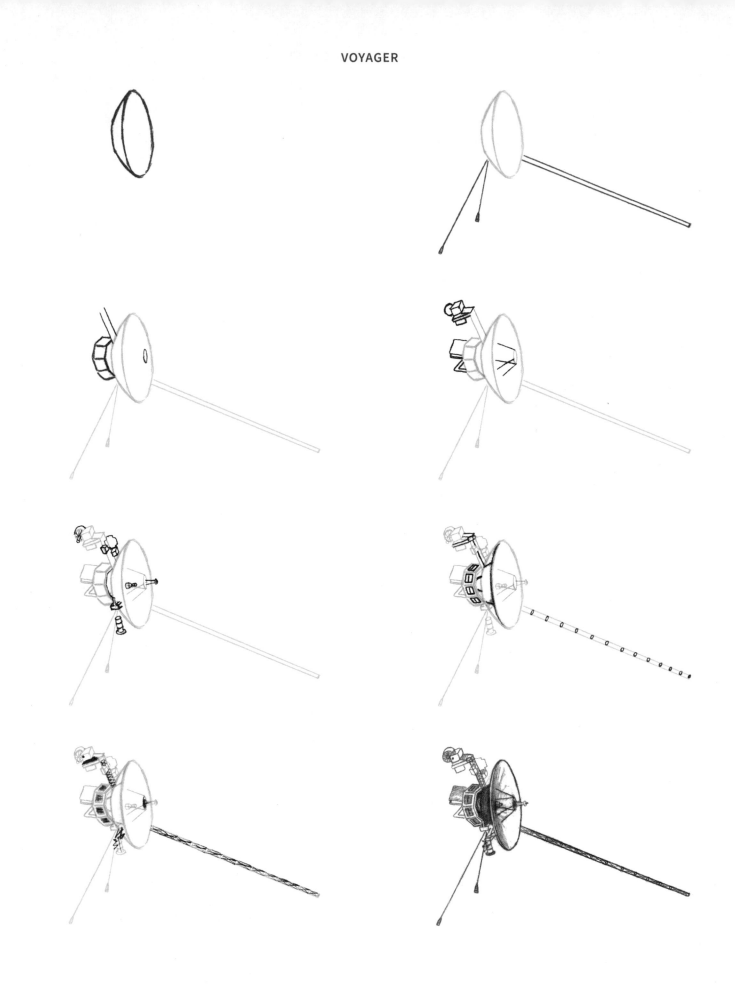

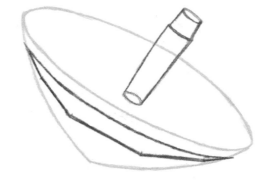

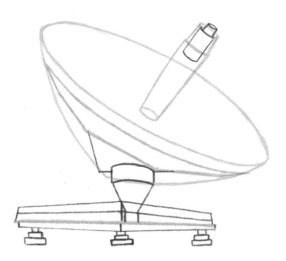

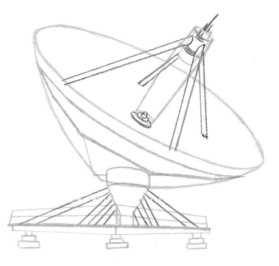

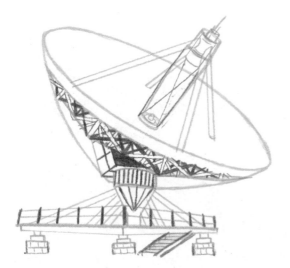

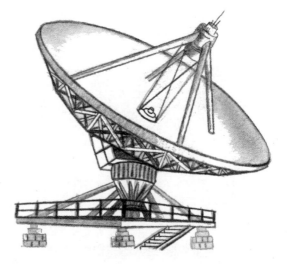

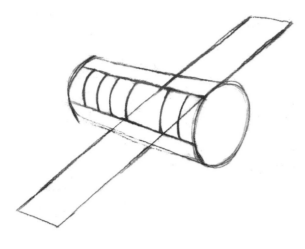

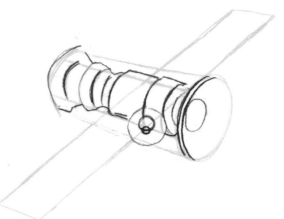

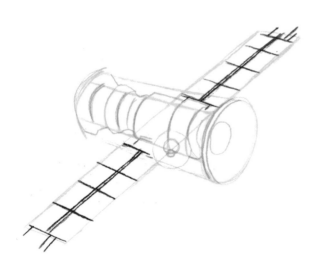

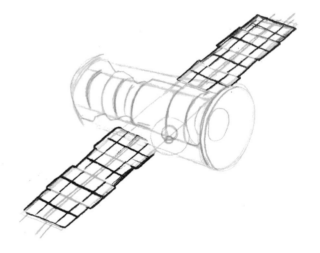

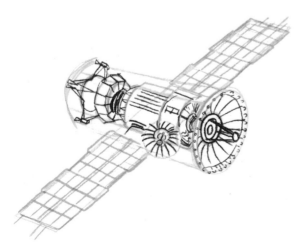

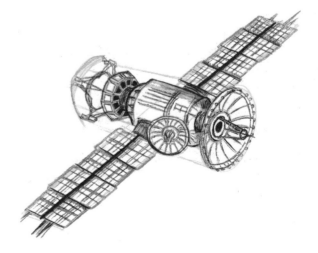

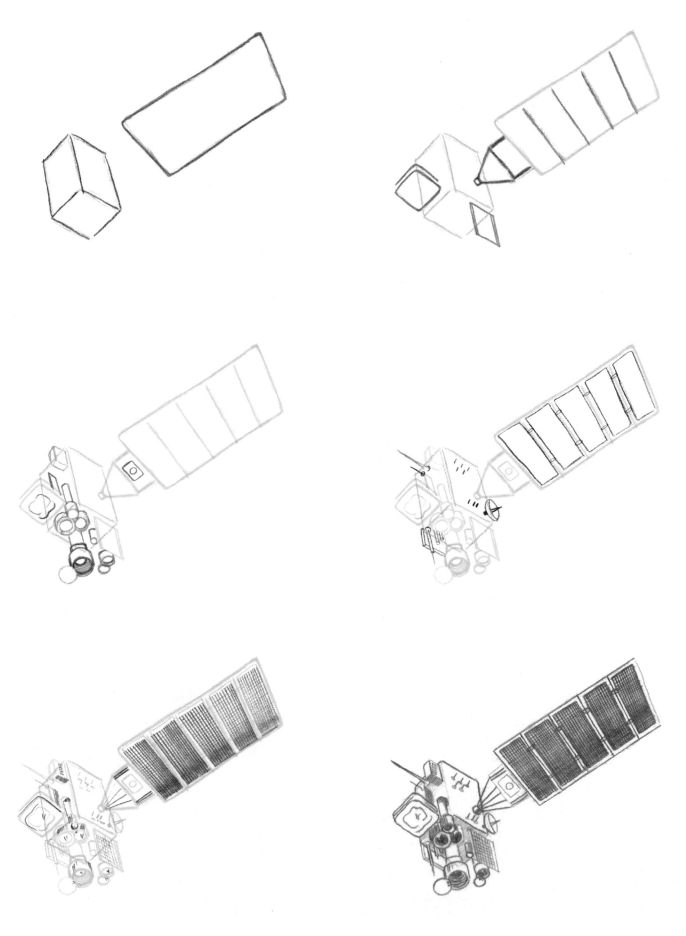

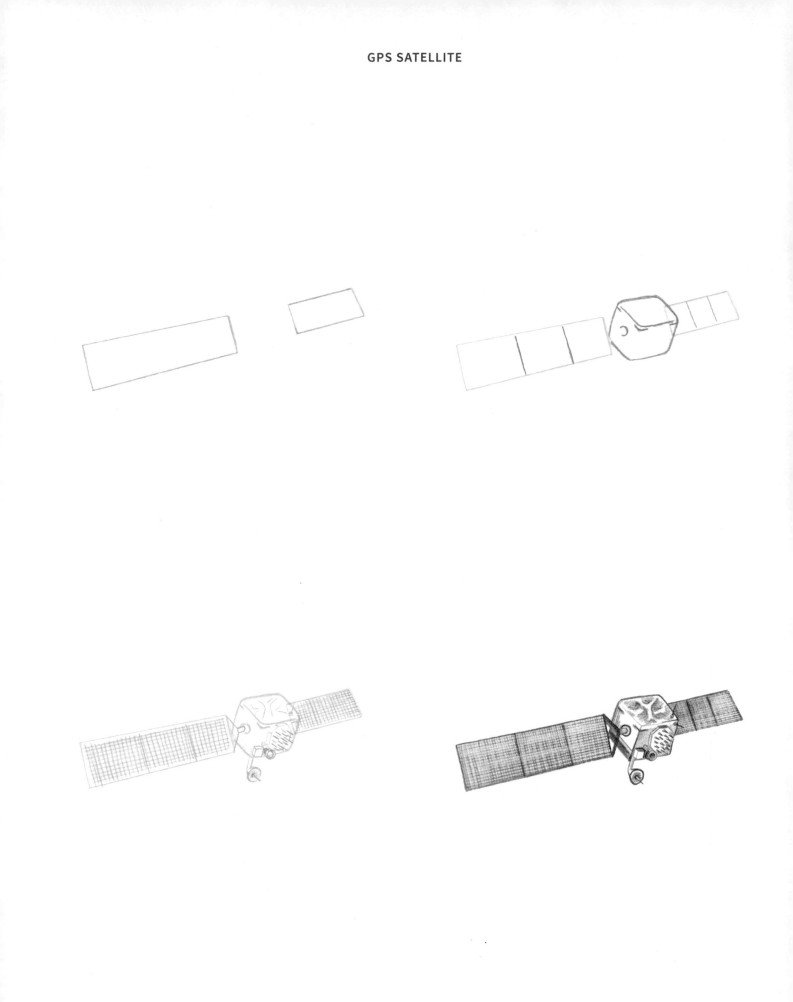

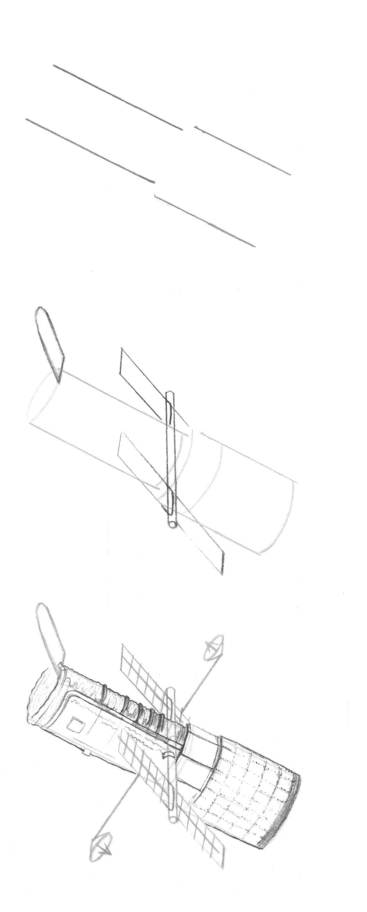

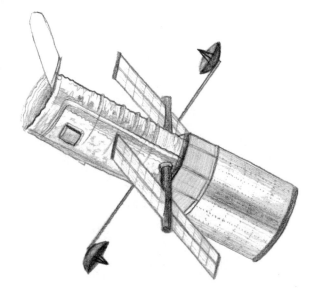

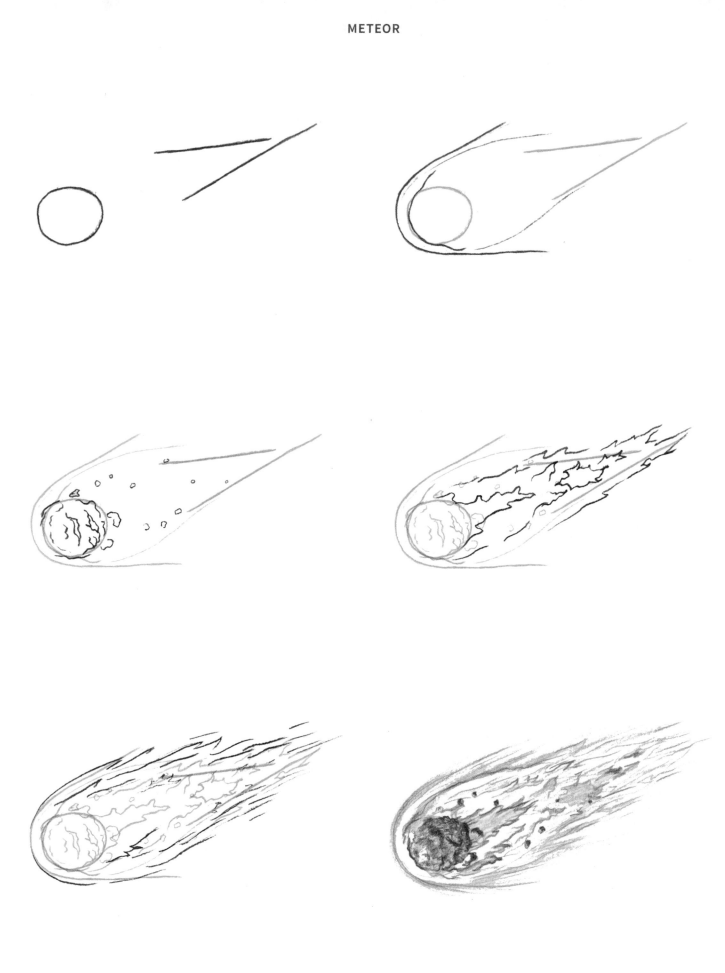

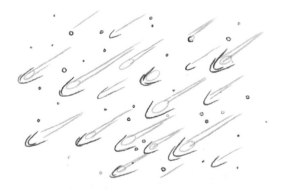

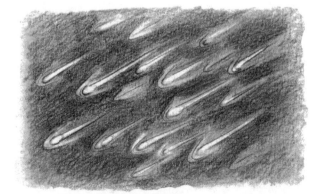

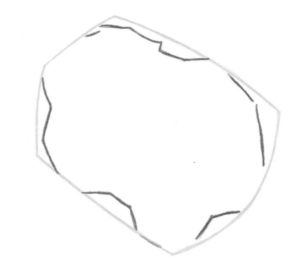

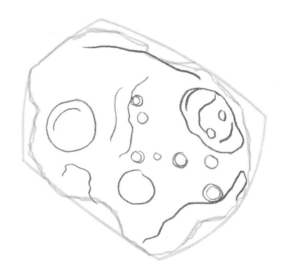

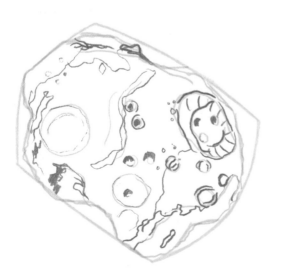

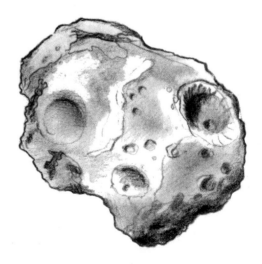

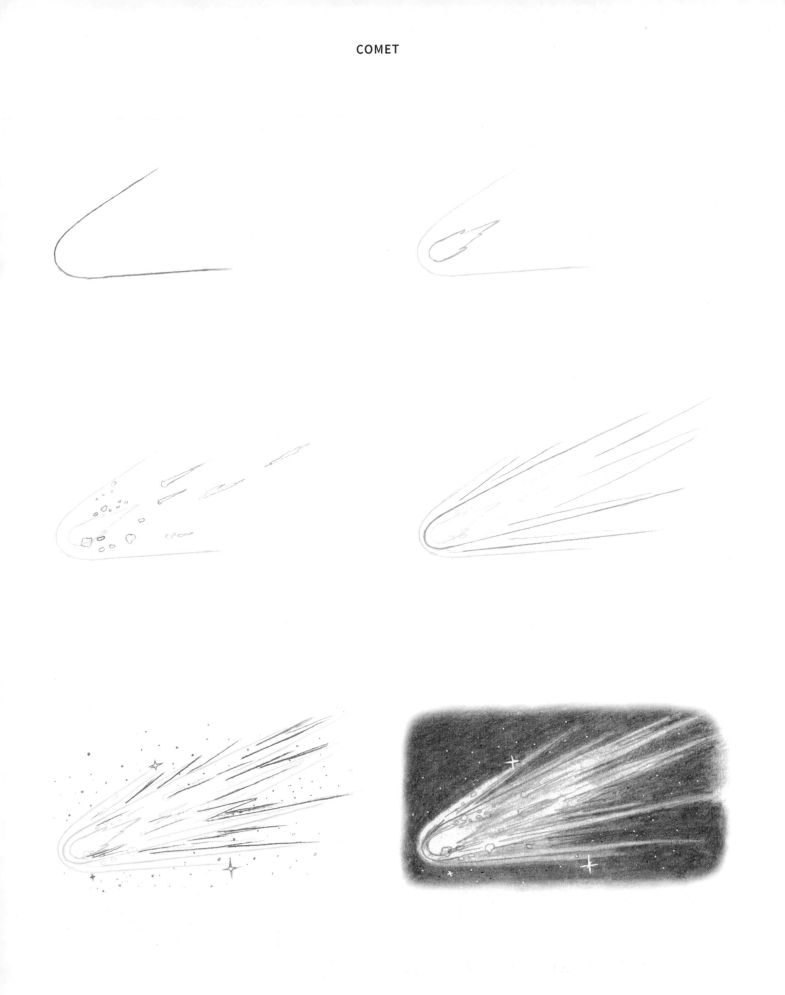

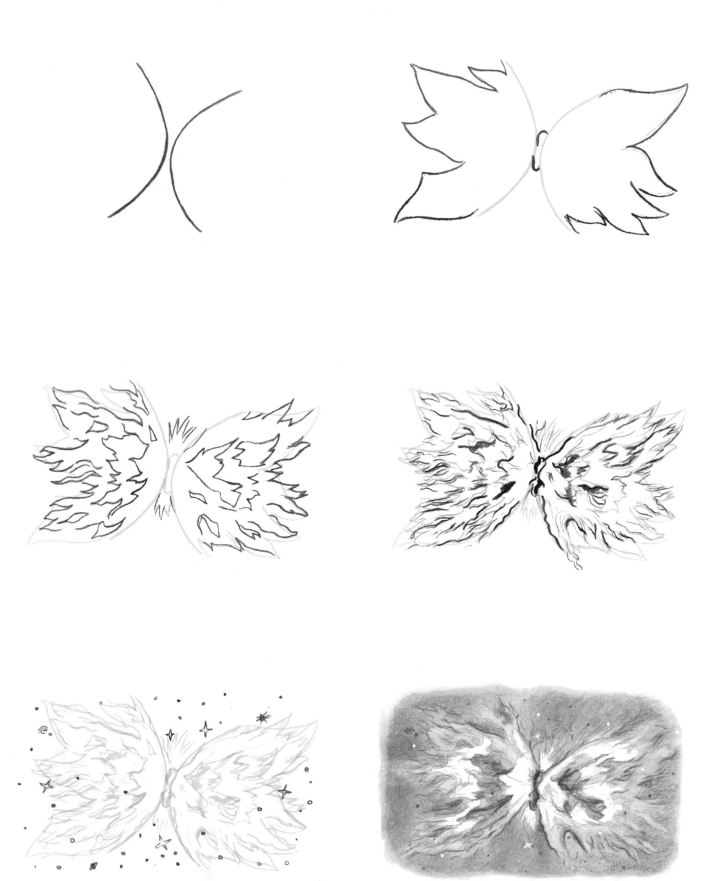

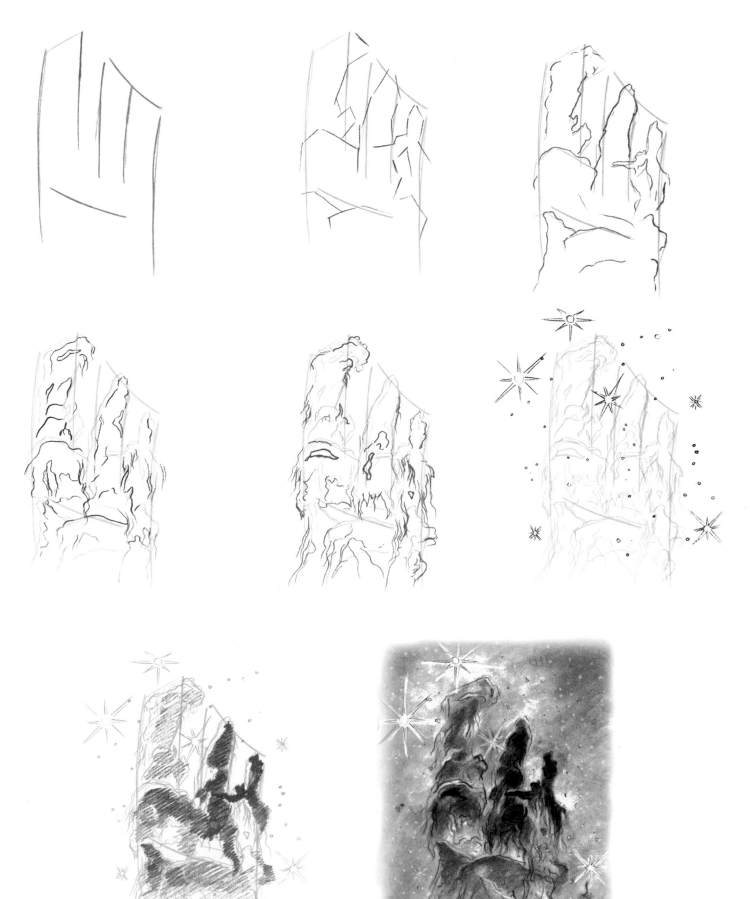

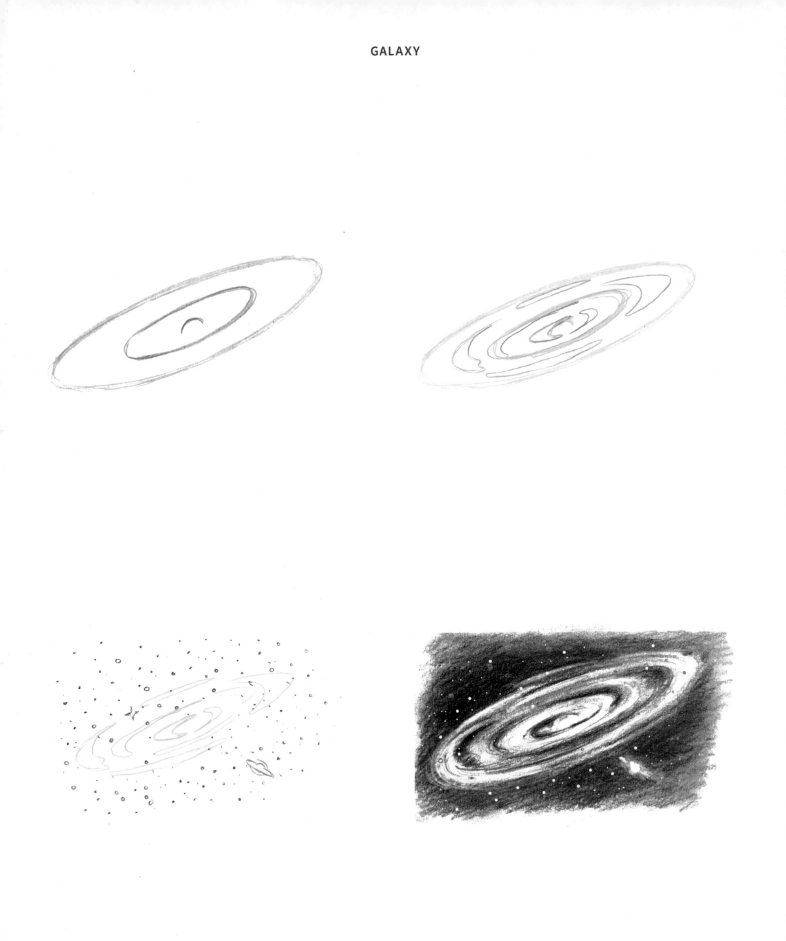

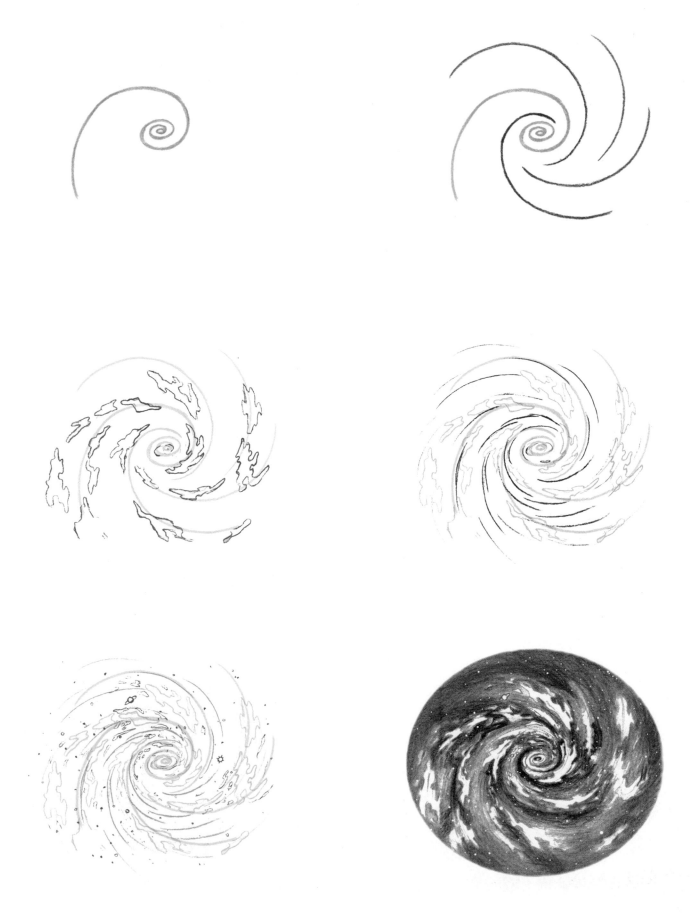

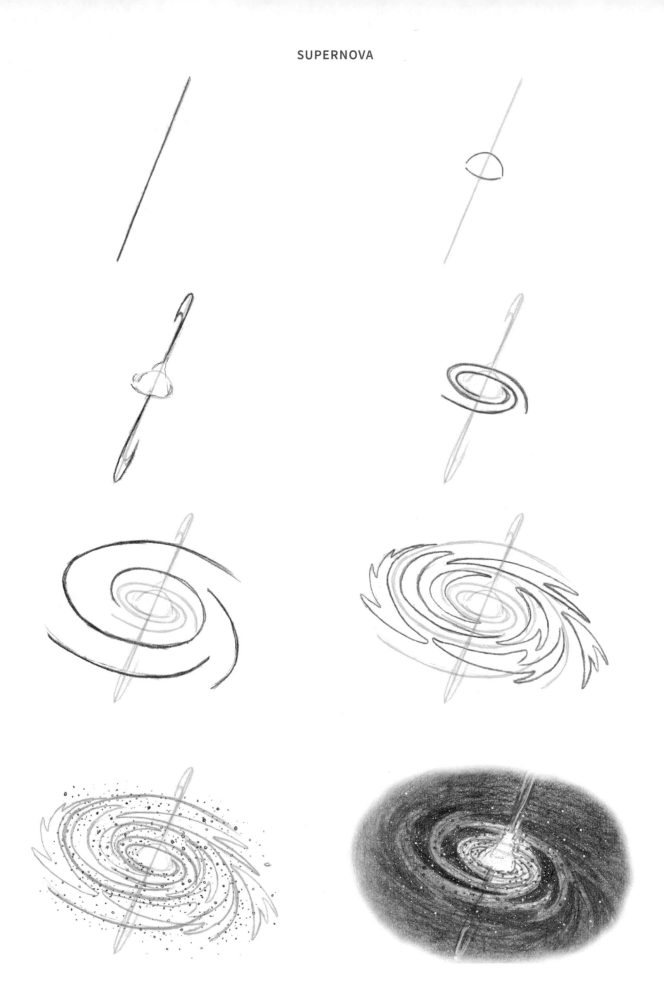

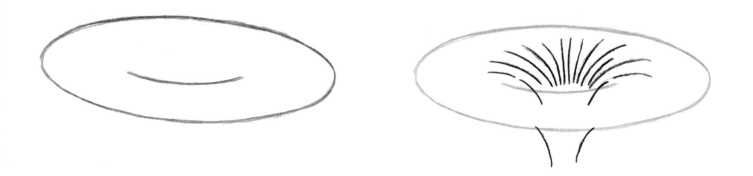

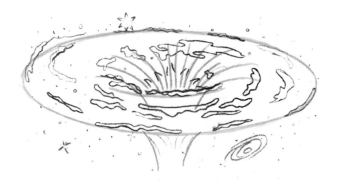

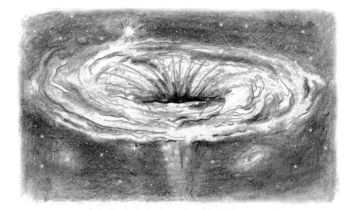

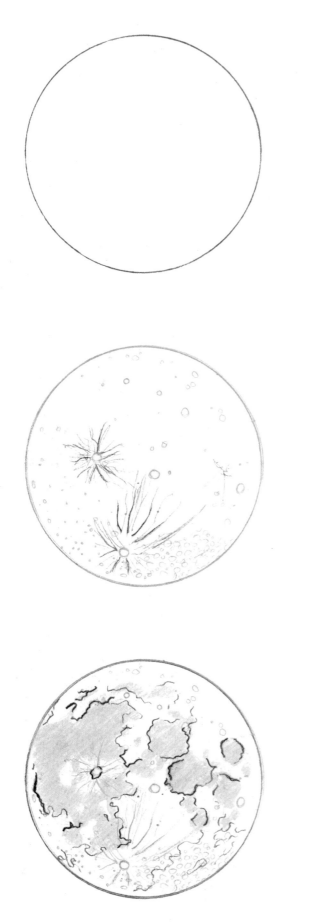

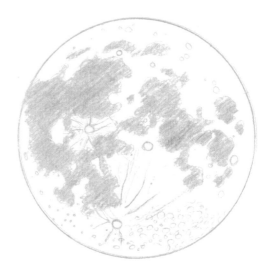

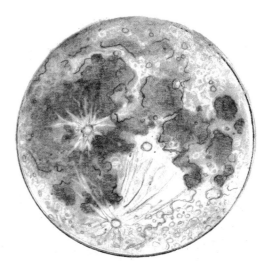

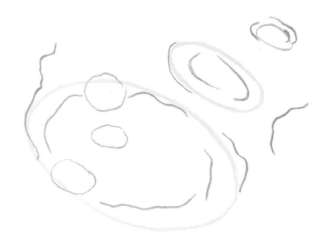

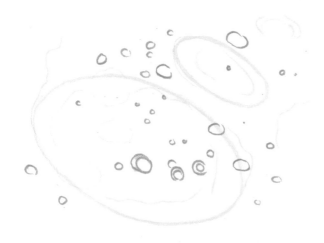

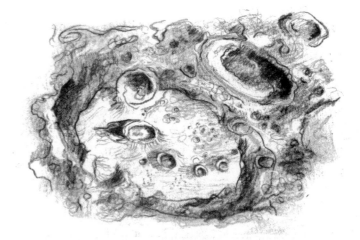

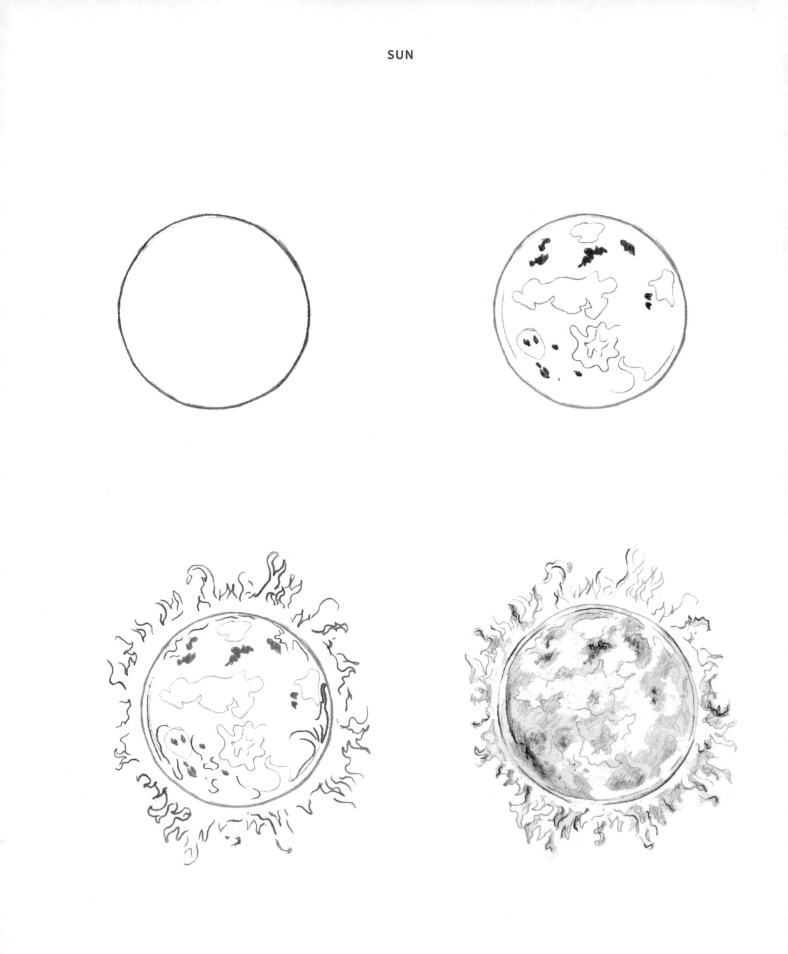

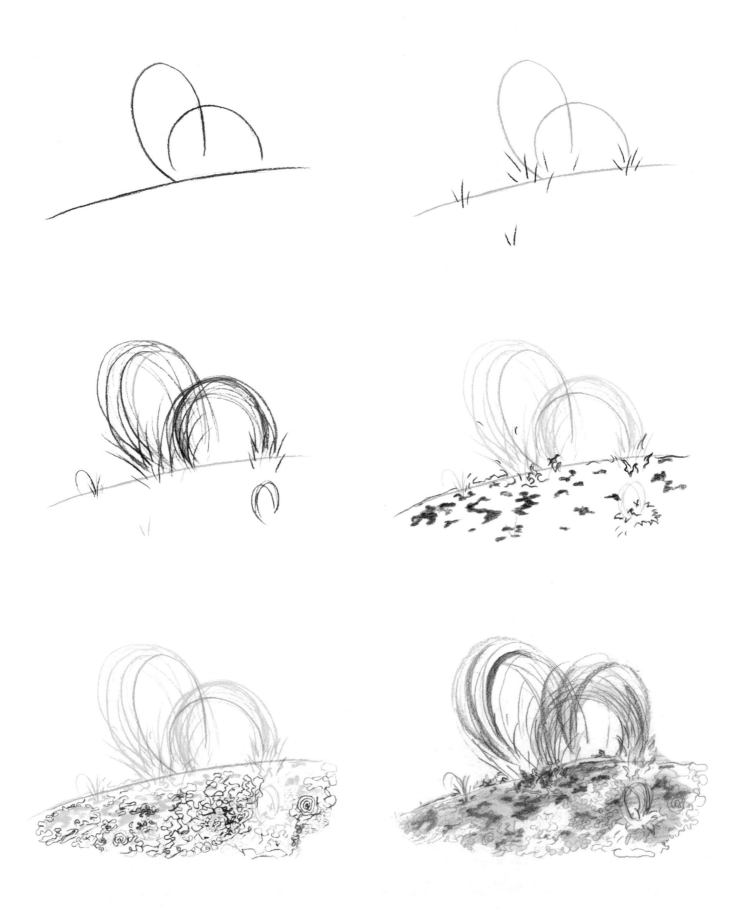

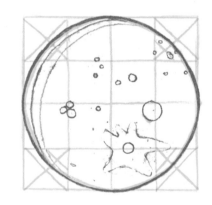
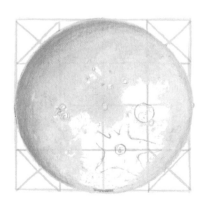
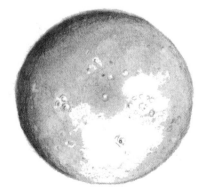

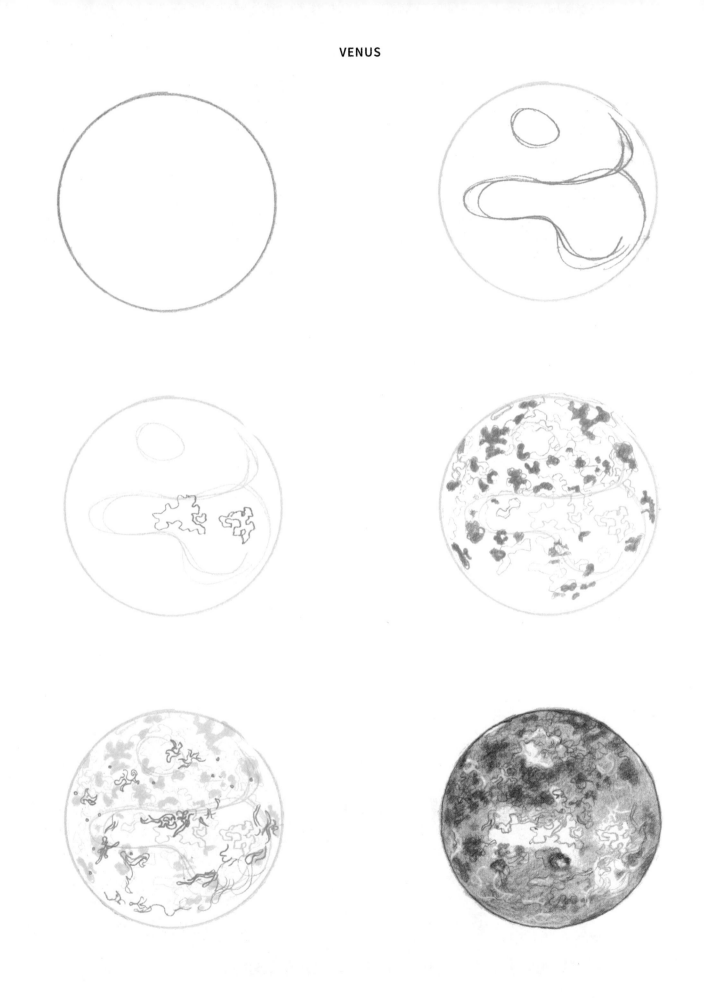

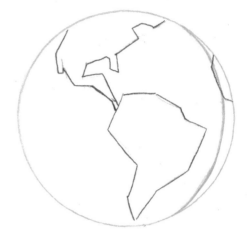

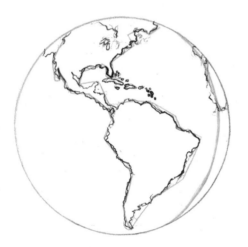

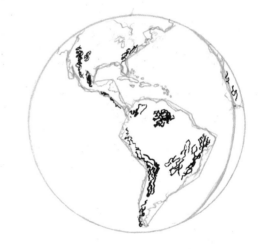

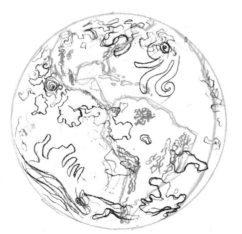

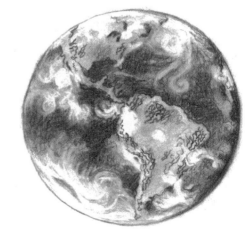

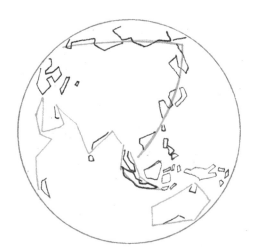

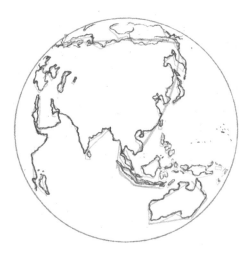

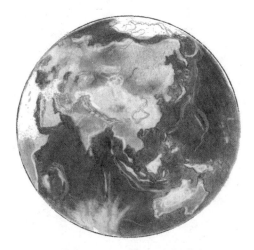

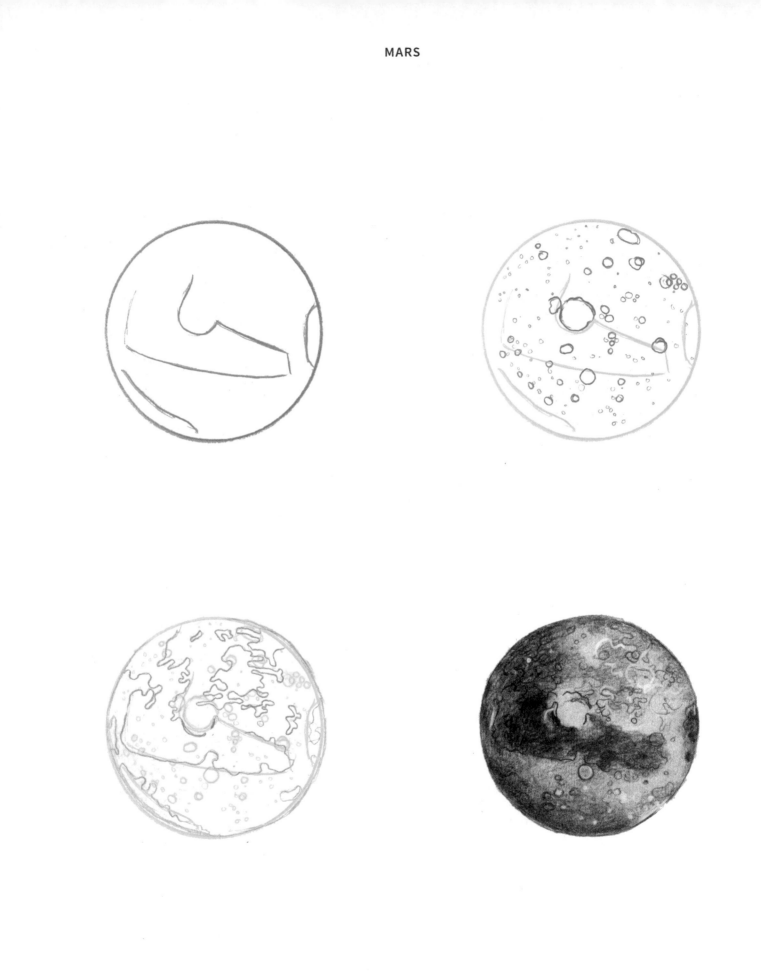

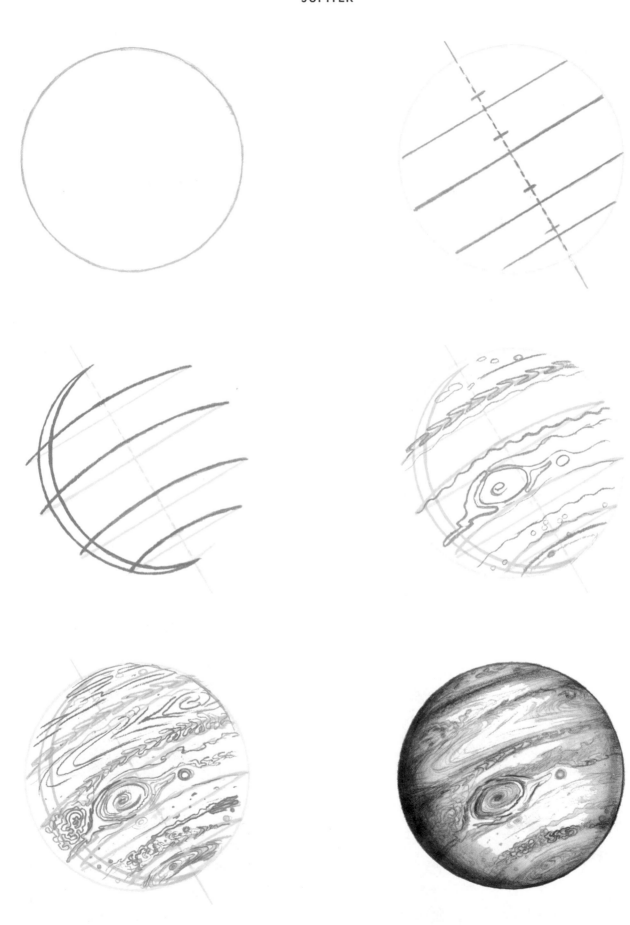

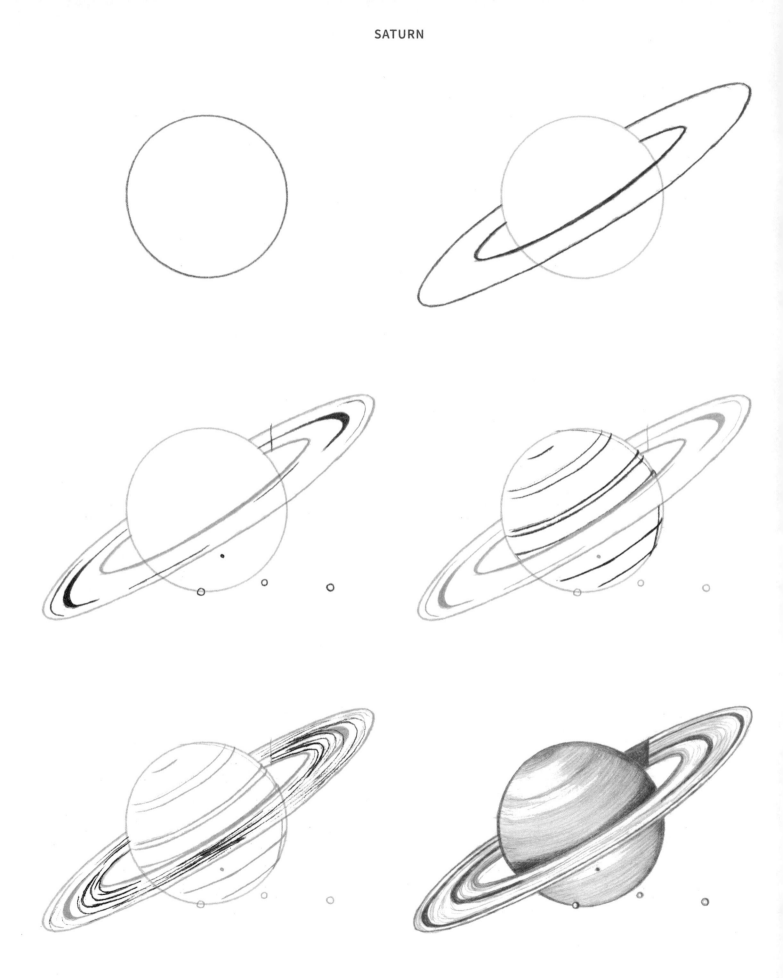

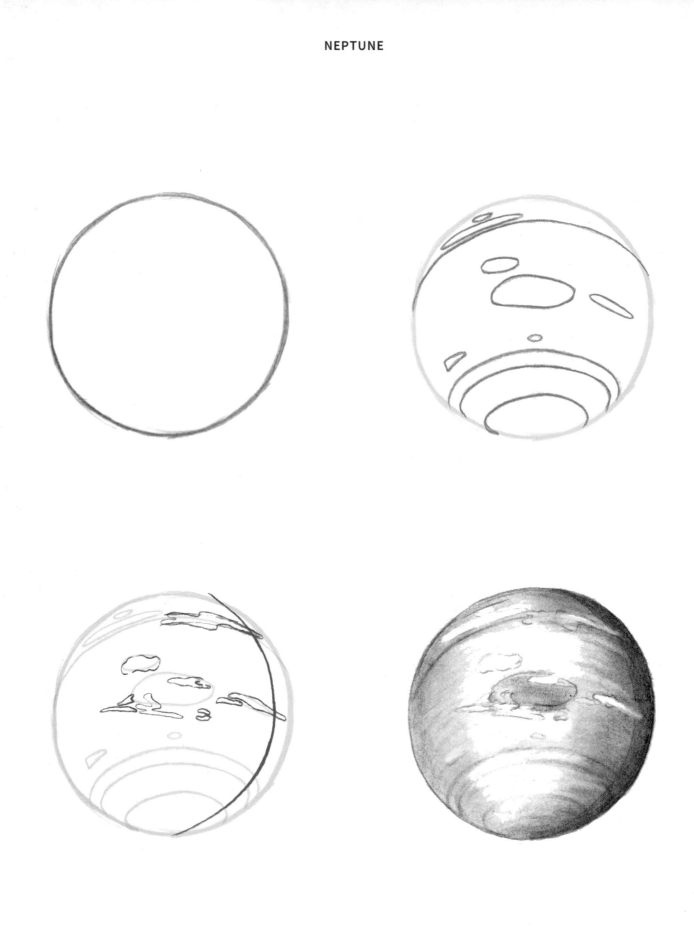

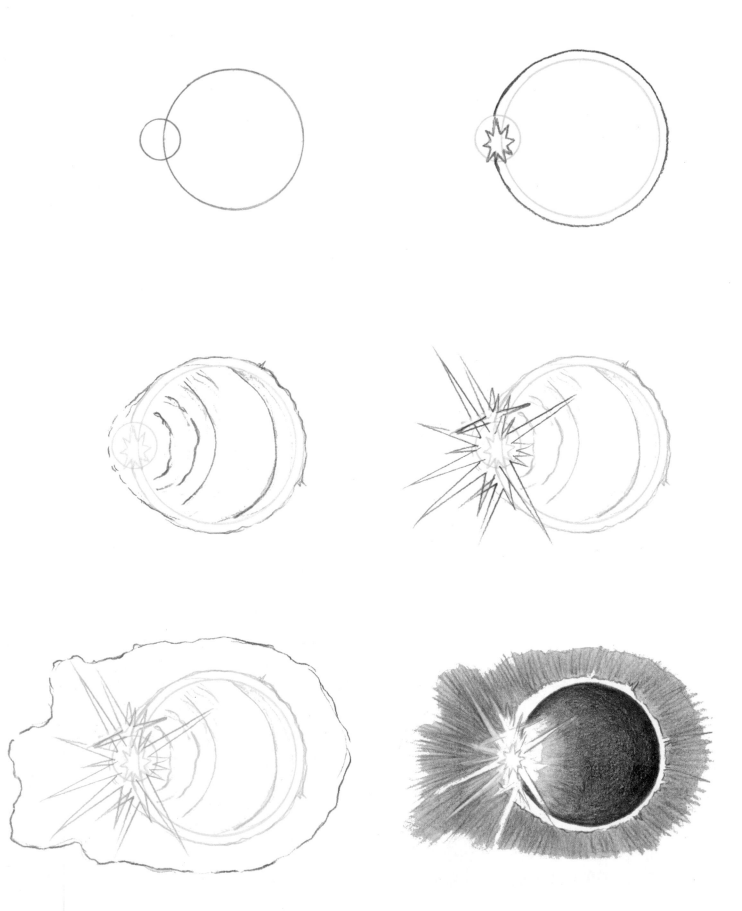

ABOUT THE AUTHOR AND ILLUSTRATOR

Lee J. Ames began his career at the Walt Disney Studios, working on films such as *Fantasia* and *Pinocchio*. He taught at the School of Visual Arts in Manhattan, and at Dowling College on Long Island, New York. An avid worker, Ames directed his own advertising agency, illustrated for several magazines, and illustrated approximately 150 books that range from picture books to postgraduate texts. He resided in Dix Hills, Long Island, with his wife, Jocelyn, until his death in June 2011.

Erin Harvey is an artist who works primarily in pencils, charcoals, oils, and pen and ink. She lives outside Atlanta with her husband, Ben, and their two children.

EXPERIENCE ALL THAT THE DRAW 50 SERIES HAS TO OFFER!

With this proven, step-by-step method, Lee J. Ames has taught millions how to draw everything from amphibians to automobiles. Now it's your turn! Pick up a pencil, get out some paper, and learn to draw everything under the sun with the Draw 50 series.

Also available:

- Draw 50 Airplanes, Aircraft, and Spacecraft
- Draw 50 Aliens
- Draw 50 Animals
- Draw 50 Animal 'Toons
- Draw 50 Athletes
- Draw 50 Baby Animals
- Draw 50 Beasties
- Draw 50 Birds
- Draw 50 Boats, Ships, Trucks, and Trains
- Draw 50 Buildings and Other Structures
- Draw 50 Cars, Trucks, and Motorcycles
- Draw 50 Cats
- Draw 50 Creepy Crawlies
- Draw 50 Dinosaurs and Other Prehistoric Animals
- Draw 50 Dogs
- Draw 50 Endangered Animals
- Draw 50 Famous Cartoons
- Draw 50 Flowers, Trees, and Other Plants
- Draw 50 Horses
- Draw 50 Magical Creatures
- Draw 50 Monsters
- Draw 50 People
- Draw 50 Princesses
- Draw 50 Sea Creatures
- Draw 50 Sharks, Whales, and Other Sea Creatures
- Draw 50 Vehicles
- Draw the Draw 50 Way

Published in the United States by Watson-Guptill Publications, an imprint of the
Crown Publishing Group, a division of Penguin Random House LLC, New York.
www.crownpublishing.com
www.watsonguptill.com

WATSON-GUPTILL and the WG and Horse designs are registered trademarks
of Penguin Random House LLC

Library of Congress Cataloging-in-Publication Data
Names: Ames, Lee J., author. | Harvey, Erin.
Title: Draw 50 outer space : the step-by-step way to draw astronauts, rockets, space stations,
 planets, meteors, comets, asteroids, and more / by Lee J. Ames with Erin Harvey.
Other titles: Draw fifty outer space
Description: California : Watson-Guptill, 2017.
Identifiers: LCCN 2017017752 | Subjects: LCSH: Drawing—Technique—Juvenile literature. |
 Outer space—In art—Juvenile literature. | BISAC: ART / Techniques / Drawing. | ART / Study & Teaching. |
 SCIENCE / Astronomy.
Classification: LCC NC825.O9 A435 2017 | DDC 741.2—dc23
LC record available at https://lccn.loc.gov/2017017752

Trade Paperback ISBN: 978-0-399-58019-2
eBook ISBN: 978-0-399-58020-8

Printed in the United States of America

Design by Chloe Rawlins

10 9 8 7 6 5 4 3 2 1

First Edition